DOG

PUPPY

CHIEN

CANE

HUND

CHIOT

WELPE

HOND

D1310313

THIS BOOK BELONGS TO:

Morgan May Suggs

MY DOG RECORD BOOK

RACHAEL HALE

Bulfinch Press

New York • Boston

CONTENTS

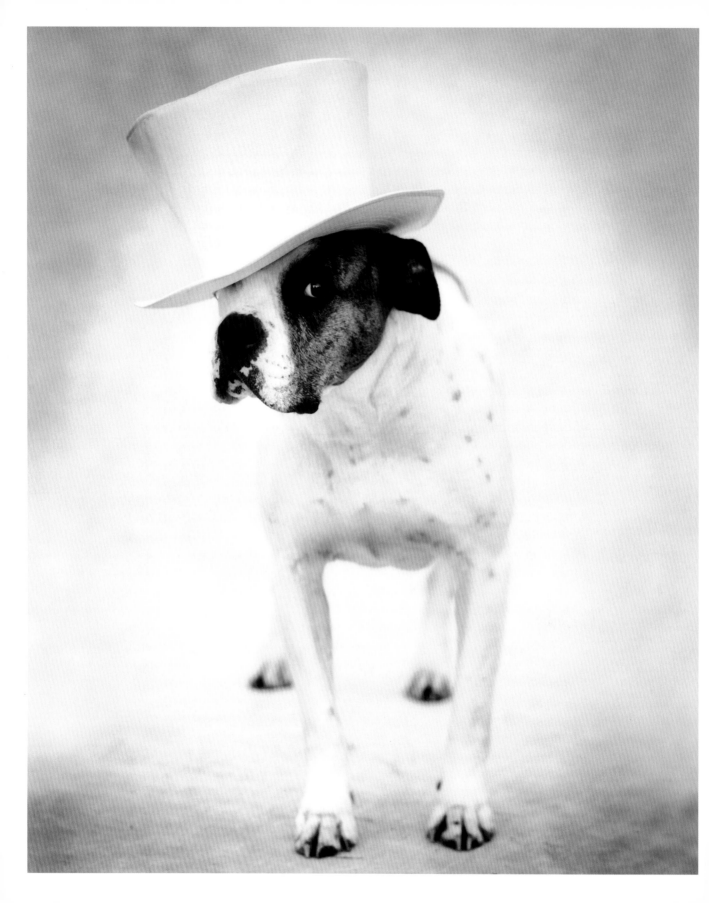

PREPARATION

COLLAR

IDENTITY TAG

LEASH

BED

FOOD BOWL

WATER BOWL

BRUSHES AND COMBS

TOYS

SUITABLE PUPPY FOOD

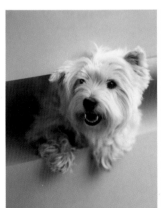
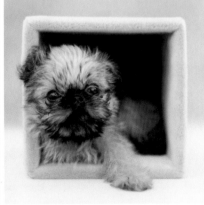
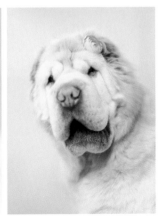

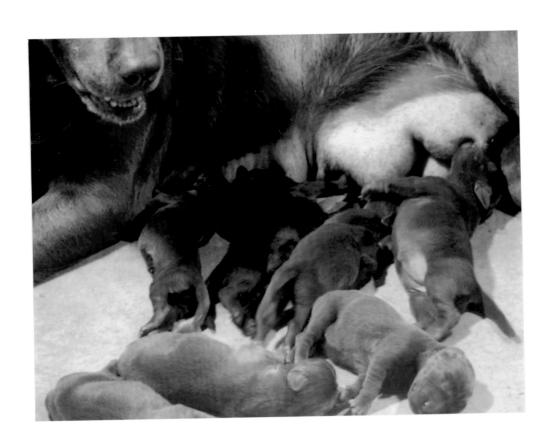

I was born on May 17, 2008

There were puppies in my litter

Date I came home July 4, 2008

Address of family home 3030 Belmont Drive
Moody, AL 35004

CHOOSING MY NAME

Names that were considered

Riley
Bailey

Inspiration for my name

Morgan is the name
of a character in
Disney's Enchanted
movie

I am a Chocolate Labrador Retriever

We are known for being gentle, intelligent and energetic.

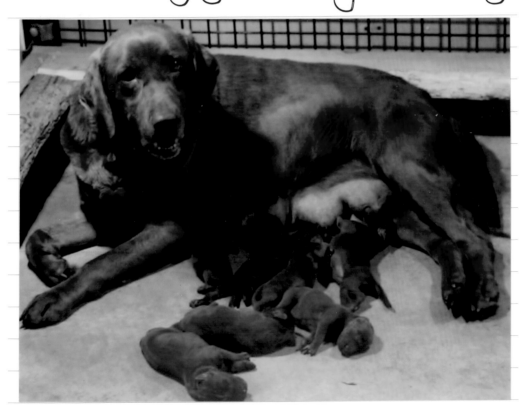

My mom, Ellie, and my siblings. We were just a couple of days old in this photo.

BEST FEATURES

My eyes are

changing color!.
First blue/grey,
then green, now
brown

My tail is

always wagging :)

My ears are

velvet looking
and soft

My fur is

soft, shiny and
smooth

GRANDFATHER

Birthplace

Date

FATHER "Cole"
Stillwaters Tomarrow's Dream
Birthplace
Date March 10, 2006

FAMILY TREE

GRANDMOTHER

Birthplace

Date

MOTHER "Ellie"
Ellie May Heflin

Birthplace

Date January 18, 2003

PLACE PHOTO
HERE

My owner is **Jamon Suggs and Kaysha Patel**

We live at **3030 Belmont Drive Moody, AL 35004**

Family members

Other pets

Other relatives

Neighbors **Jim and Linda Wood
Johnathan Schaffer
Jason and Jennifer Lawley**

GROWING UP

3 months- Learned "sit" and "come"
4-5 months- Learned "lay down", "paw"
5 months- Learned roll over

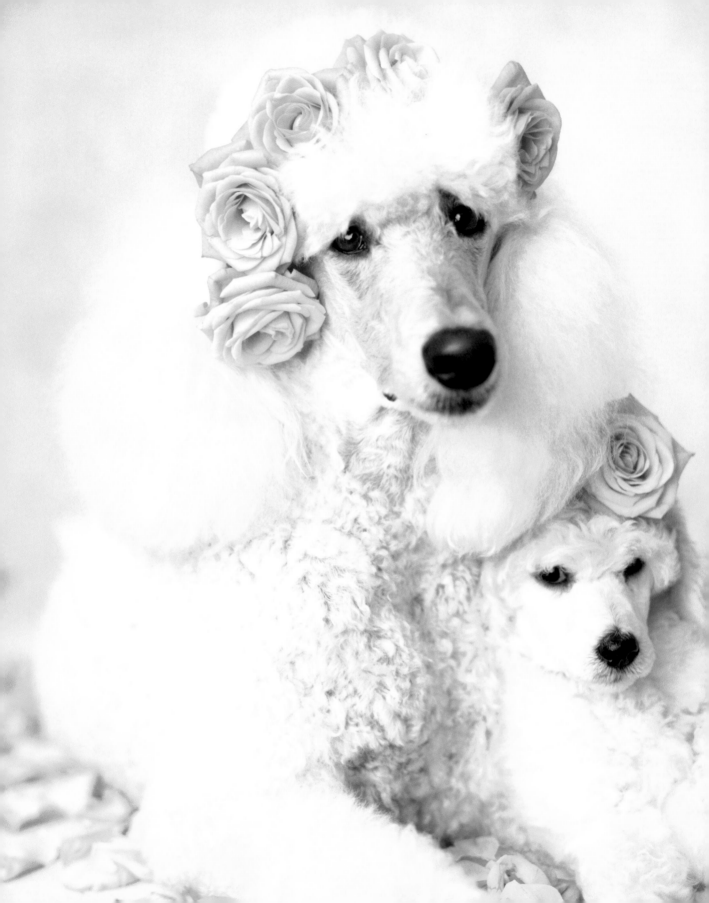

SPECIAL MOMENTS

8/9/08 - Noticed Morgan
lost 4 baby teeth.
Two front top and bottom.

BIRTHDAYS

Year

Gifts

Party guests

Year

Gifts

Party guests

Year

Gifts

Party guests

Year

Gifts

Party guests

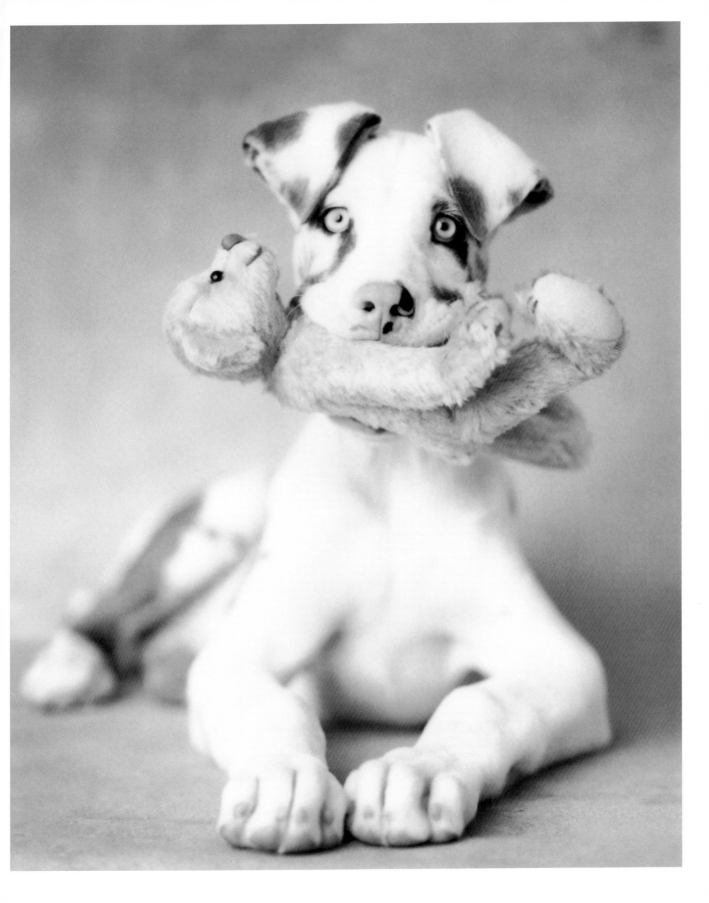

PLACE PHOTO
HERE

Year

Gifts

Party guests

Year

Gifts

Party guests

Year

Gifts

Party guests

Year

Gifts

Party guests

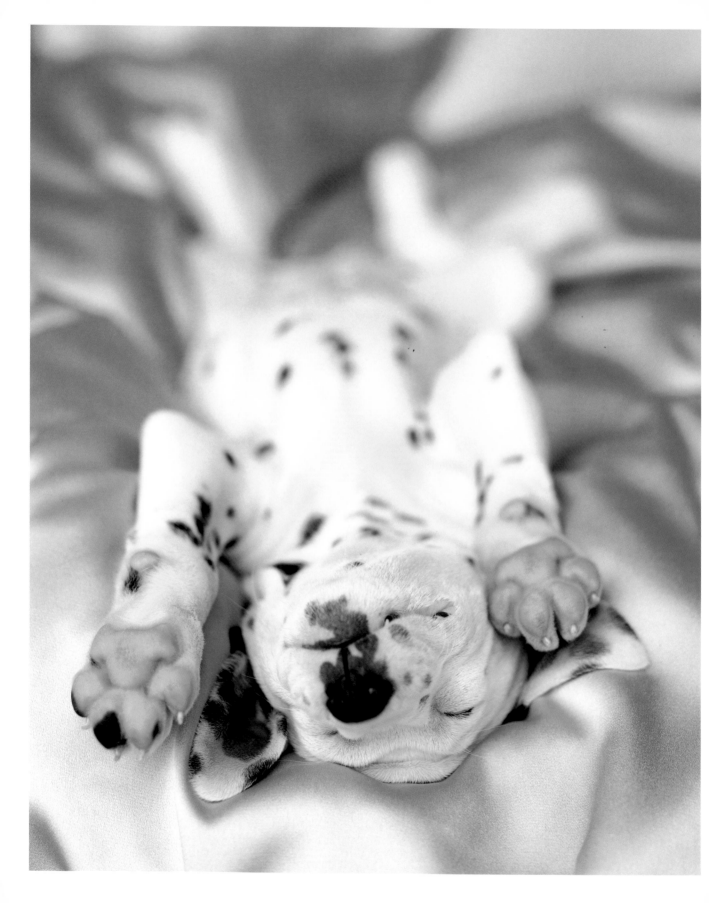

Stuffed squeaky lamb
Red flashing ball
Pink squeaky stuffed dog
Water bottles
Green squeaky Teddy Bear
Green squeaky cuz ball

BEST FRIENDS

Name _Dixie_

Name _____

What we do together

Run around

What we do together

Name

What we do together

Name

What we do together

PLACE PHOTO
HERE

MY FAVORITE FOOD

Loves rawhide bones
Loves Beggin' strips and canine carry out
treats.

In my crate
Under the patio table in the shade
Under the grill cover
Under the desk in the office
On the patio chairs

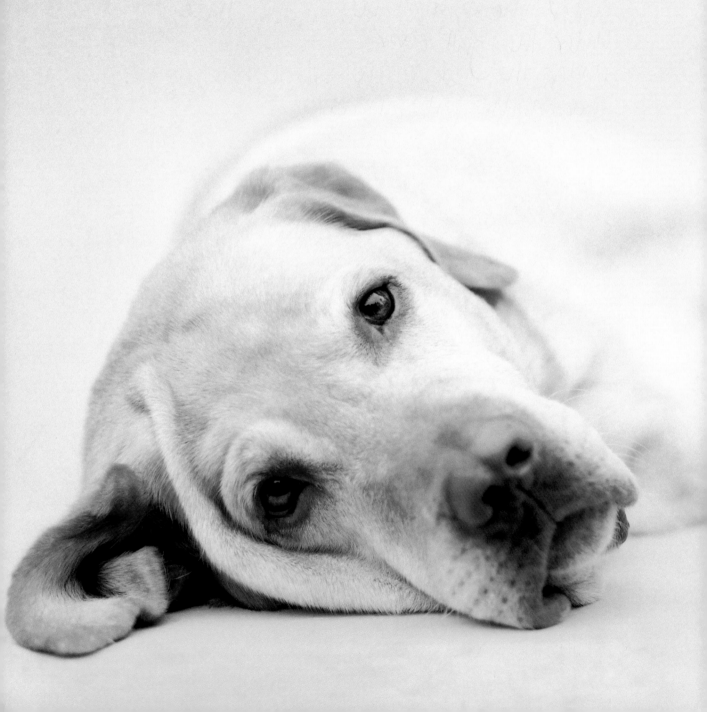

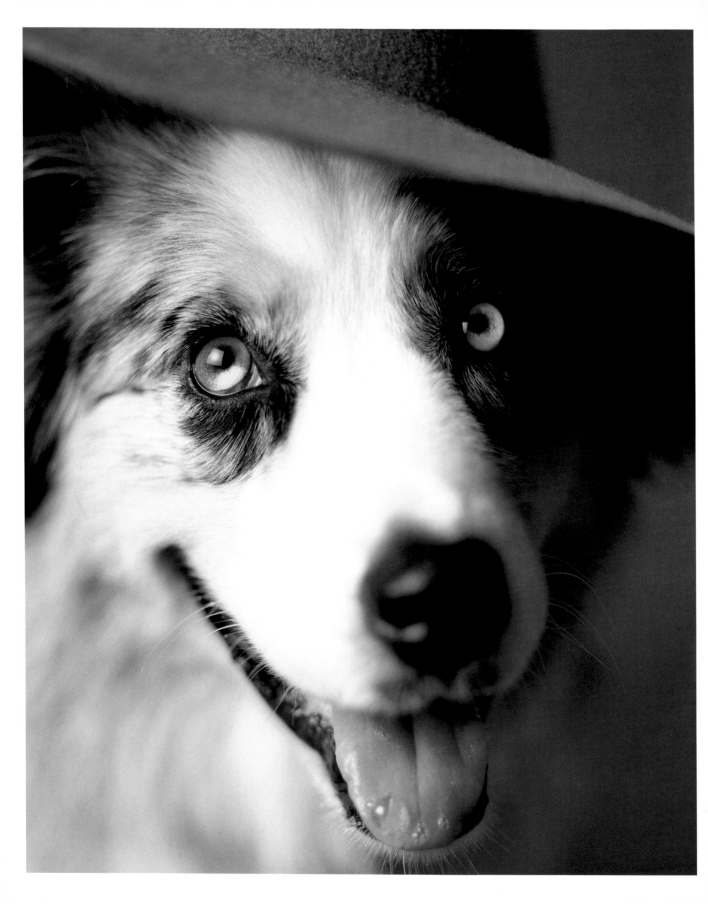

PLACE PHOTO
HERE

Saturday September 6, 2008 – Boarded at the vet for the first time.

Sept 12-16, 2008 – Boarded when Mom and Dad go to the beach

TOP SPOTS

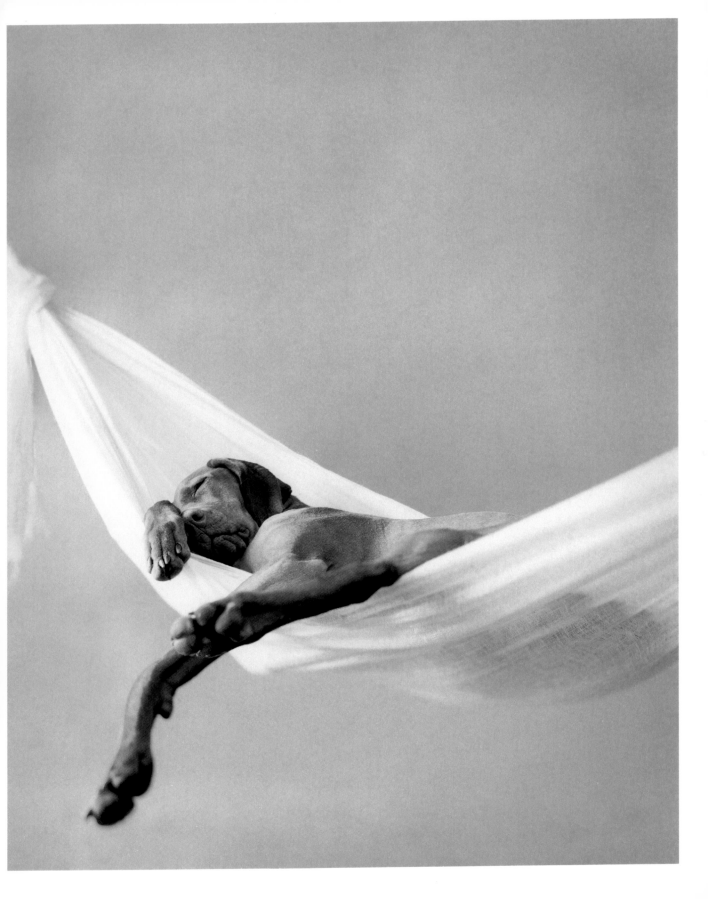

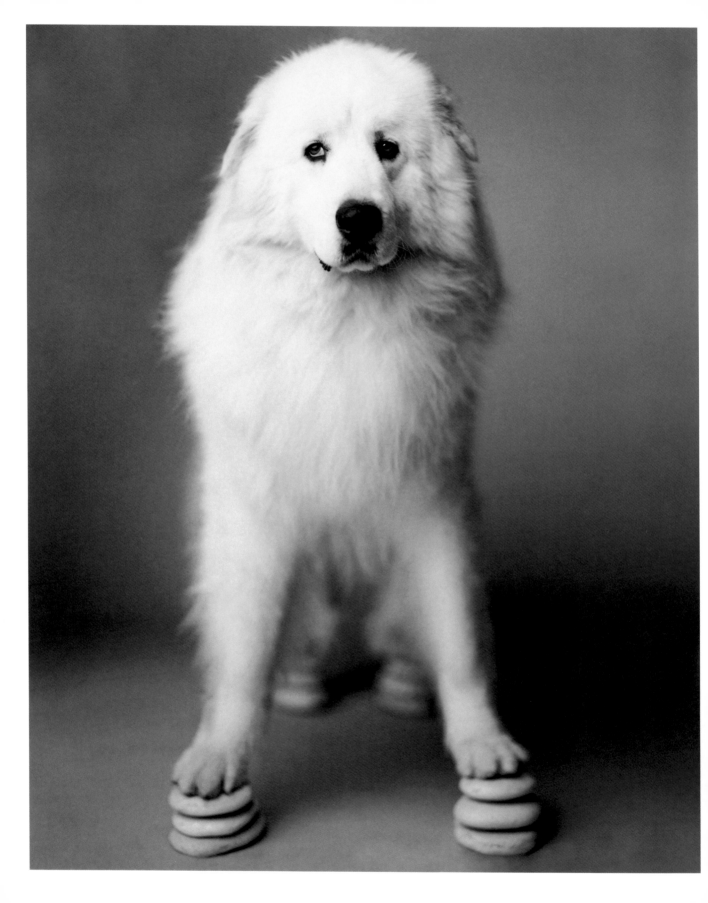

ANNOYING HABITS

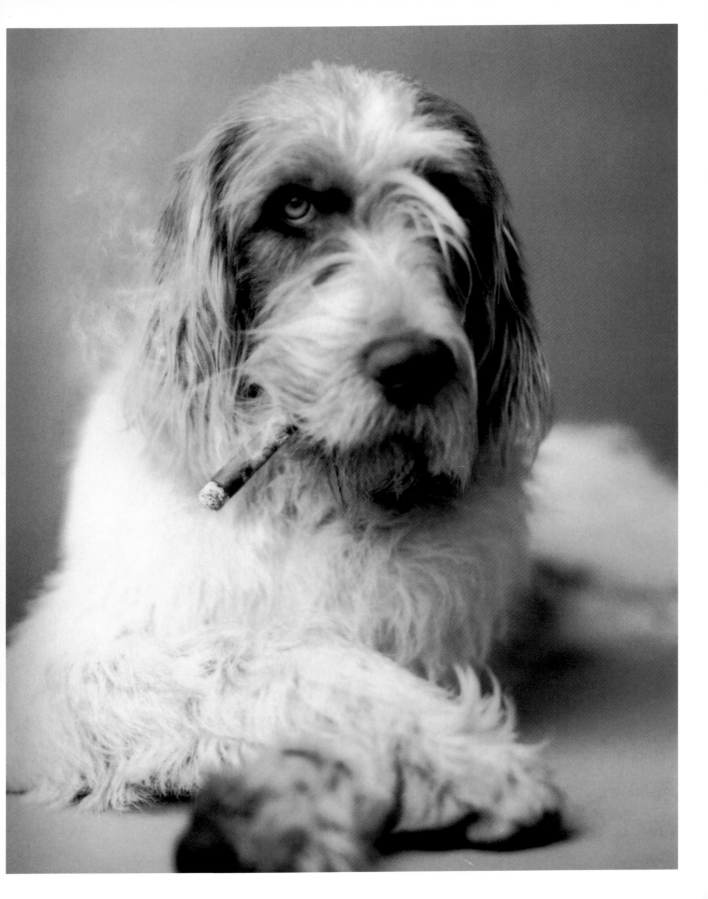

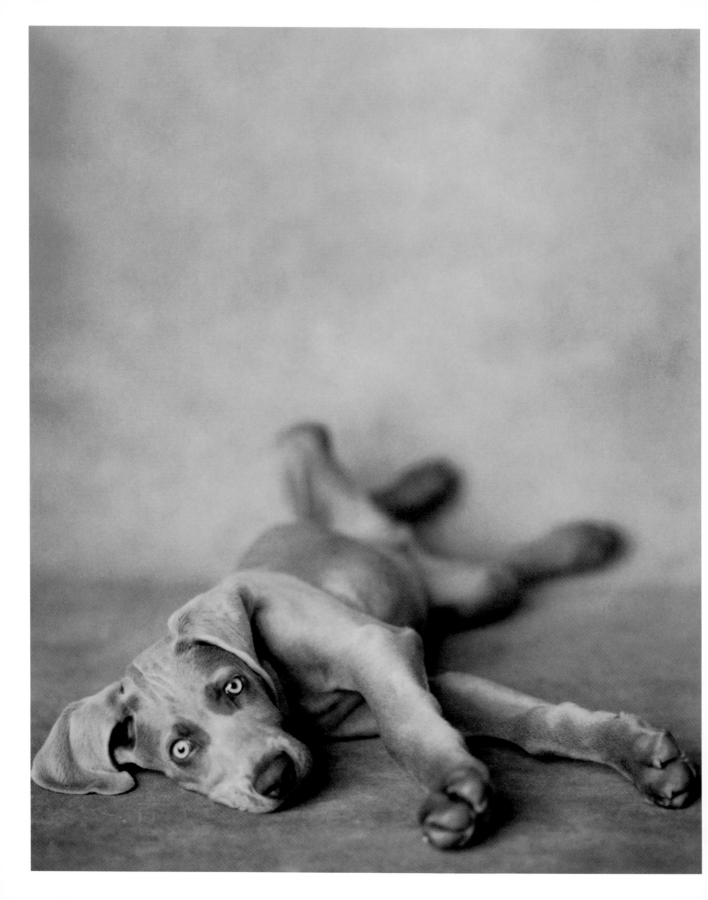

GROOMING

PLACE PHOTO
HERE

BATH TIME

Morgan does not like getting baths at all.

Once she drank so much bath water and got so worked up that she threw up after getting a bath.

Mommy did not like having to clean up the bathroom and all the hair in the tub, so she started taking me to Pawsnclaws, a grooming place in Odenville.

PAW PRINTS

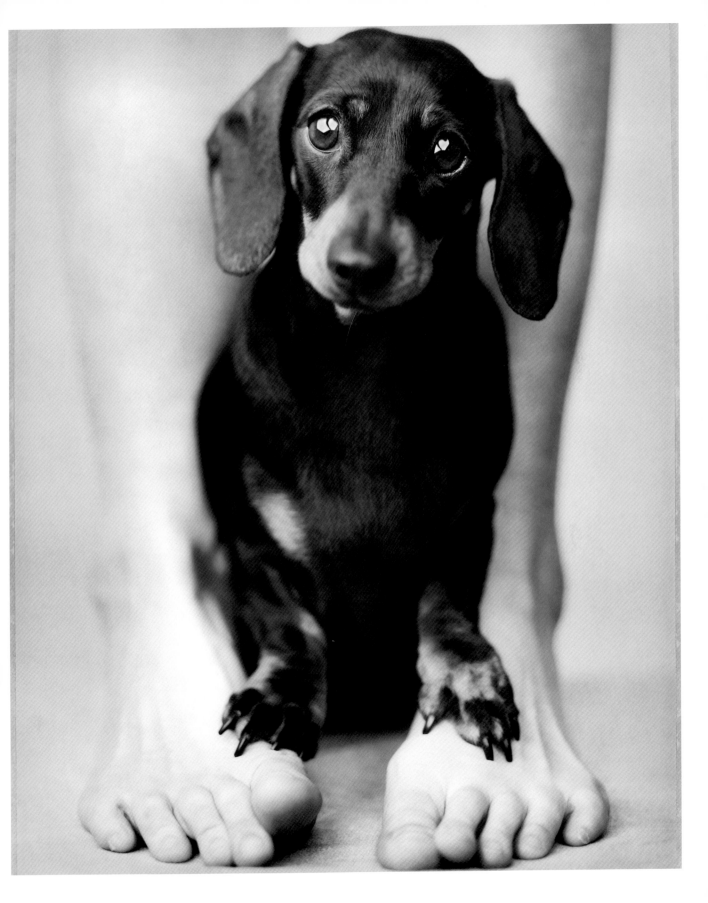

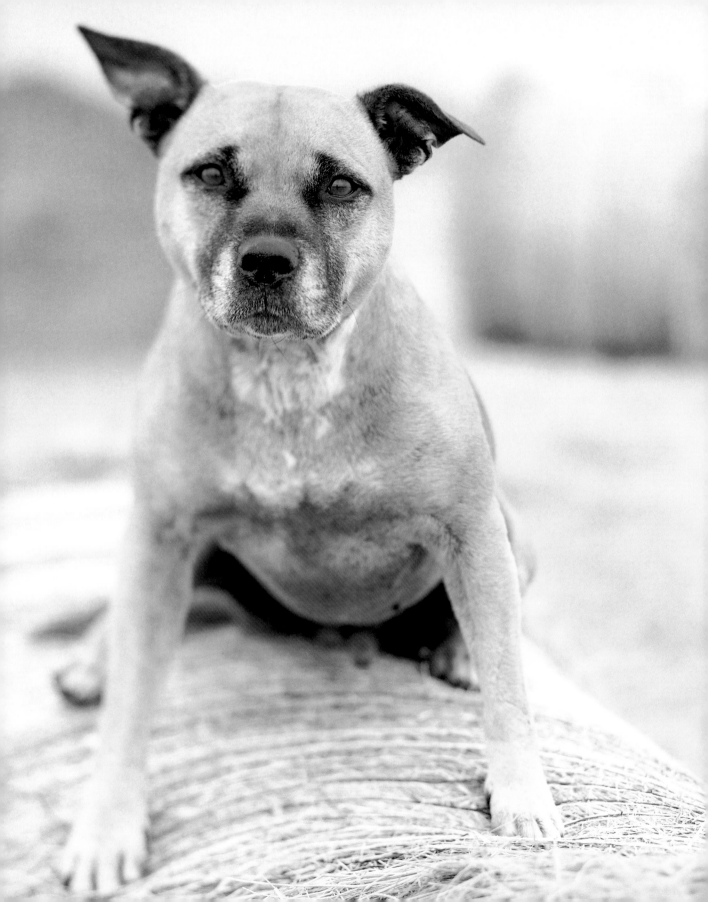

TRAINING

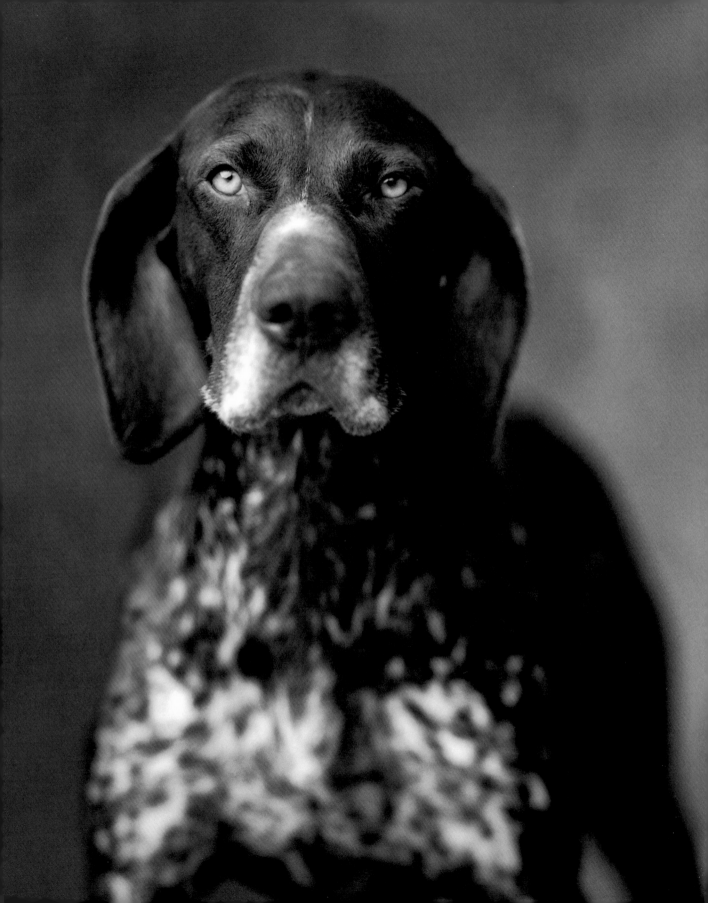

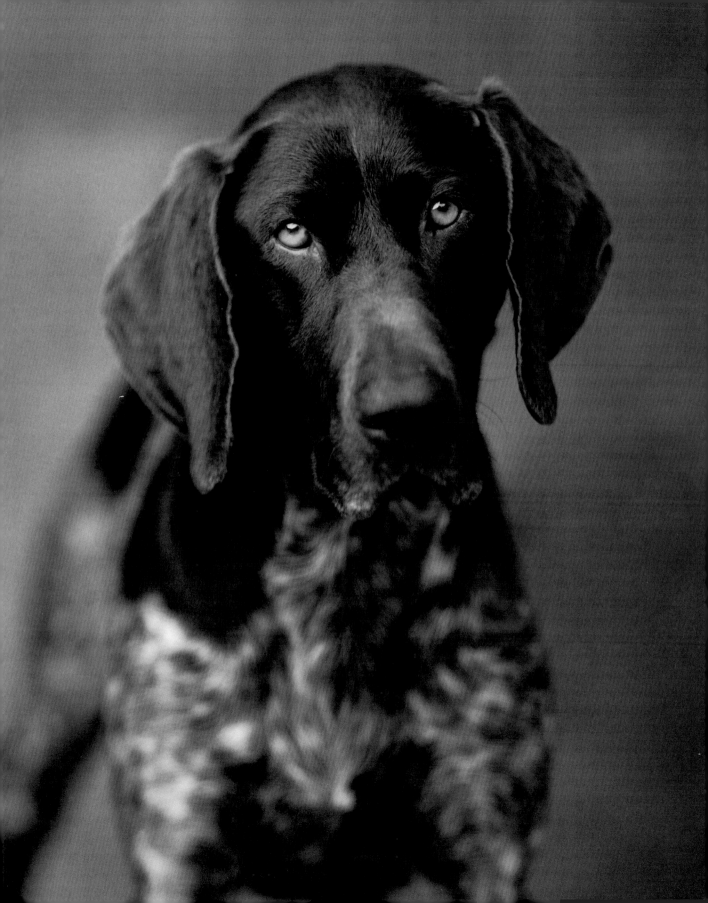

Likes riding in the car to Gigi and Pop's House

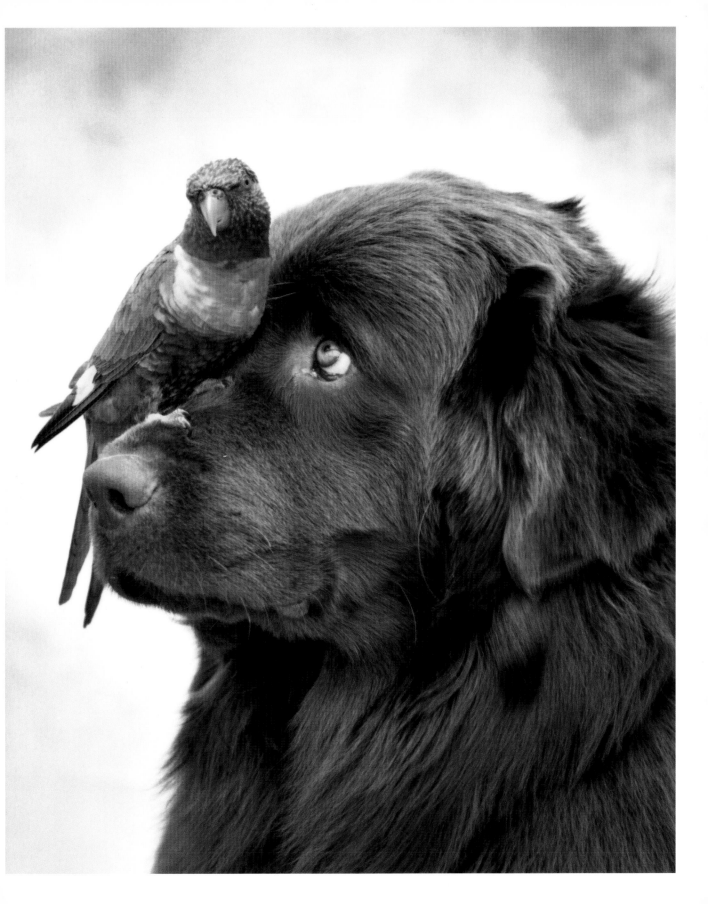

PLACE PHOTO
HERE

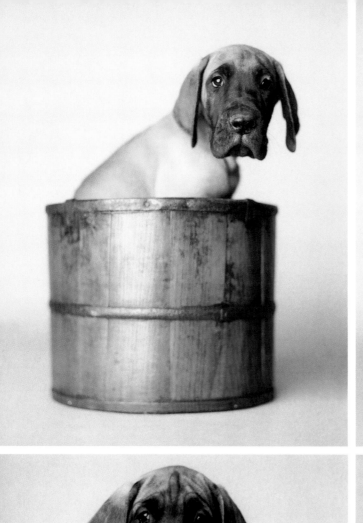

Flea Treatments

Date	Date	Date	Date
Aug 1, 2008			
Sept			
Oct 3, 2008			
Nov 1, 2008			
Dec 1, 2008			

VISITS TO THE VET

Date	Illness	Treatment
12/11/08	Getting spayed	

WORMING

Date _____ Date _____ Date _____ Date _____

_____ _____ _____ _____

_____ _____ _____ _____

_____ _____ _____ _____

_____ _____ _____ _____

_____ _____ _____ _____

_____ _____ _____ _____

_____ _____ _____ _____

_____ _____ _____ _____

_____ _____ _____ _____

_____ _____ _____ _____

_____ _____ _____ _____

_____ _____ _____ _____

_____ _____ _____ _____

_____ _____ _____ _____

_____ _____ _____ _____

_____ _____ _____ _____

VACCINATION

Date	Vaccine	Date	Vaccine
7/3/08	Distemper		
	Adenovirus		
	Parainfluenza		
	Parvo		
7/26/08	Bordetella		
	Distemper		
	Adenovirus		
	Parainfluenza		
	Parvo		
8/16/08	Bordetella		
	Distemper		
	Adenovirus		
	Parainfluenza		
	Parvo		
9/15/08	Rabies		
	DA2PPV Booster		

IMPORTANT ADDRESSES

Name **Diane and William Cox**
Address **3584 AL Hwy 174**
Springville, AL 35146
Phone **205 467 0258** Email: **Equest32@aol.com**

Name **Dr Rachel Nelson - Crossroads Animal Hospital**
Address **1826 Carl Jones Road**
Moody, AL 35004
Phone **205 640 4327**

Name
Address

Phone

Name
Address

Phone

Nathalie Giacomelli

Bulfinch Press

Time Warner Book Group
1271 Avenue of the Americas, New York, NY 10020
Visit our Web site at www.bulfinchpress.com

First North American Edition

Published by arrangement with PQ Publishers Limited

ISBN 0-8212-5698-X
Library of Congress Control Number 2004113257

Designed by Kylie Nicholls

PRINTED IN CHINA

DOG

PUPPY

CHIEN

CANE

HUND

CHIOT

WELPE

HOND